YES I Can!
(THIS WEEK PLANNING)

Goals:

From _____ to _____

MONDAY

TUESDAY

WEDNESDAY

THURSDAY

FRIDAY

SATURDAY

SUNDAY

NOTES

YES
I Can!
(THIS WEEK PLANNING)

Goals:

FROM _____ TO _____

MONDAY

TUESDAY

WEDNESDAY

THURSDAY

FRIDAY

SATURDAY

SUNDAY

NOTES

YES I Can!
(THIS WEEK PLANNING)

Goals:

From _____ to _____

MONDAY

TUESDAY

WEDNESDAY

THURSDAY

FRIDAY

SATURDAY

SUNDAY

NOTES

YES
I Can!
(THIS WEEK PLANNING)

Goals:

FROM _____ TO _____

MONDAY

TUESDAY

WEDNESDAY

THURSDAY

FRIDAY

SATURDAY

SUNDAY

NOTES

YES
I Can!
(THIS WEEK PLANNING)

Goals:

FROM _____ TO _____

MONDAY

TUESDAY

WEDNESDAY

THURSDAY

FRIDAY

SATURDAY

SUNDAY

NOTES

YES
I Can!
(THIS WEEK PLANNING)

Goals:

FROM _____ TO _____

MONDAY

TUESDAY

WEDNESDAY

THURSDAY

FRIDAY

SATURDAY

SUNDAY

NOTES

YES
I Can!
(THIS WEEK PLANNING)

Goals:

From _____ to _____

MONDAY

TUESDAY

WEDNESDAY

THURSDAY

FRIDAY

SATURDAY

SUNDAY

NOTES

YES
I Can!
(THIS WEEK PLANNING)

Goals:

FROM _____ TO _____

MONDAY

TUESDAY

WEDNESDAY

THURSDAY

FRIDAY

SATURDAY

SUNDAY

NOTES

YES
I Can!
(THIS WEEK PLANNING)

FROM _____ TO _____

Goals:

MONDAY

TUESDAY

WEDNESDAY

THURSDAY

FRIDAY

SATURDAY

SUNDAY

NOTES

YES
I Can!
(THIS WEEK PLANNING)

Goals:

FROM _____ TO _____

MONDAY

TUESDAY

WEDNESDAY

THURSDAY

FRIDAY

SATURDAY

SUNDAY

NOTES

YES
I Can!
(THIS WEEK PLANNING)

Goals:

FROM _____ TO _____

MONDAY

TUESDAY

WEDNESDAY

THURSDAY

FRIDAY

SATURDAY

SUNDAY

NOTES

YES I Can!
(THIS WEEK PLANNING)

Goals:

FROM _____ TO _____

MONDAY

TUESDAY

WEDNESDAY

THURSDAY

FRIDAY

SATURDAY

SUNDAY

NOTES

YES
I Can!
(THIS WEEK PLANNING)

Goals:

FROM _____ TO _____

MONDAY

TUESDAY

WEDNESDAY

THURSDAY

FRIDAY

SATURDAY

SUNDAY

NOTES

YES
I Can!
(THIS WEEK PLANNING)

Goals:

FROM _____ TO _____

MONDAY

TUESDAY

WEDNESDAY

THURSDAY

FRIDAY

SATURDAY

SUNDAY

NOTES

YES
I Can!
(THIS WEEK PLANNING)

Goals:

FROM _____ TO _____

MONDAY

TUESDAY

WEDNESDAY

THURSDAY

FRIDAY

SATURDAY

SUNDAY

NOTES

YES
I Can!
(THIS WEEK PLANNING)

Goals:

FROM _____ TO _____

MONDAY

TUESDAY

WEDNESDAY

THURSDAY

FRIDAY

SATURDAY

SUNDAY

NOTES

YES I Can!
(THIS WEEK PLANNING)

Goals:

FROM _____ TO _____

MONDAY

TUESDAY

WEDNESDAY

THURSDAY

FRIDAY

SATURDAY

SUNDAY

NOTES

YES
I Can!
(THIS WEEK PLANNING)

Goals:

FROM _____ TO _____

MONDAY

TUESDAY

WEDNESDAY

THURSDAY

FRIDAY

SATURDAY

SUNDAY

NOTES

YES
I Can!
(THIS WEEK PLANNING)

Goals:

FROM _____ TO _____

MONDAY

TUESDAY

WEDNESDAY

THURSDAY

FRIDAY

SATURDAY

SUNDAY

NOTES

YES
I Can!
(THIS WEEK PLANNING)

Goals:

FROM _____ TO _____

MONDAY

TUESDAY

WEDNESDAY

THURSDAY

FRIDAY

SATURDAY

SUNDAY

NOTES

YES
I Can!
(THIS WEEK PLANNING)

Goals:

FROM _____ TO _____

MONDAY

TUESDAY

WEDNESDAY

THURSDAY

FRIDAY

SATURDAY

SUNDAY

NOTES

YES I Can!
(THIS WEEK PLANNING)

Goals:

FROM _____ TO _____

MONDAY

TUESDAY

WEDNESDAY

THURSDAY

FRIDAY

SATURDAY

SUNDAY

NOTES

YES
I Can!
(THIS WEEK PLANNING)

Goals:

FROM _____ TO _____

MONDAY

TUESDAY

WEDNESDAY

THURSDAY

FRIDAY

SATURDAY

SUNDAY

NOTES

YES
I Can!
(THIS WEEK PLANNING)

Goals:

FROM _____ TO _____

MONDAY

TUESDAY

WEDNESDAY

THURSDAY

FRIDAY

SATURDAY

SUNDAY

NOTES

YES
I Can!
(THIS WEEK PLANNING)

Goals:

FROM _____ TO _____

MONDAY

TUESDAY

WEDNESDAY

THURSDAY

FRIDAY

SATURDAY

SUNDAY

NOTES

YES
I Can!
(THIS WEEK PLANNING)

Goals:

FROM _____ TO _____

MONDAY

TUESDAY

WEDNESDAY

THURSDAY

FRIDAY

SATURDAY

SUNDAY

NOTES

YES
I Can!
(THIS WEEK PLANNING)

Goals:

FROM _____ TO _____

MONDAY

TUESDAY

WEDNESDAY

THURSDAY

FRIDAY

SATURDAY

SUNDAY

NOTES

YES
I Can!
(THIS WEEK PLANNING)

Goals:

FROM _____ TO _____

MONDAY

TUESDAY

WEDNESDAY

THURSDAY

FRIDAY

SATURDAY

SUNDAY

NOTES

YES
I Can!
(THIS WEEK PLANNING)

Goals:

FROM _____ TO _____

MONDAY

TUESDAY

WEDNESDAY

THURSDAY

FRIDAY

SATURDAY

SUNDAY

NOTES

YES
I Can!
(THIS WEEK PLANNING)

Goals:

FROM _____ TO _____

MONDAY

TUESDAY

WEDNESDAY

THURSDAY

FRIDAY

SATURDAY

SUNDAY

NOTES

YES
I Can!
(THIS WEEK PLANNING)

Goals:

FROM _____ TO _____

MONDAY

TUESDAY

WEDNESDAY

THURSDAY

FRIDAY

SATURDAY

SUNDAY

NOTES

YES
I Can!
(THIS WEEK PLANNING)

Goals:

FROM _____ TO _____

MONDAY

TUESDAY

WEDNESDAY

THURSDAY

FRIDAY

SATURDAY

SUNDAY

NOTES

YES I Can!
(THIS WEEK PLANNING)

FROM _____ TO _____

Goals:

MONDAY

TUESDAY

WEDNESDAY

THURSDAY

FRIDAY

SATURDAY

SUNDAY

NOTES

YES

I Can!

(THIS WEEK PLANNING)

Goals:

FROM _____ TO _____

MONDAY

TUESDAY

WEDNESDAY

THURSDAY

FRIDAY

SATURDAY

SUNDAY

NOTES

YES
I Can!
(THIS WEEK PLANNING)

Goals:

FROM _____ TO _____

MONDAY

TUESDAY

WEDNESDAY

THURSDAY

FRIDAY

SATURDAY

SUNDAY

NOTES

YES
I Can!
(THIS WEEK PLANNING)

Goals:

FROM _____ TO _____

MONDAY

TUESDAY

WEDNESDAY

THURSDAY

FRIDAY

SATURDAY

SUNDAY

NOTES

YES
I Can!
(THIS WEEK PLANNING)

Goals:

From _____ to _____

MONDAY

TUESDAY

WEDNESDAY

THURSDAY

FRIDAY

SATURDAY

SUNDAY

NOTES

YES
I Can!
(THIS WEEK PLANNING)

Goals:

From _____ to _____

MONDAY

TUESDAY

WEDNESDAY

THURSDAY

FRIDAY

SATURDAY

SUNDAY

NOTES

YES
I Can!
(THIS WEEK PLANNING)

Goals:

FROM _____ TO _____

MONDAY

TUESDAY

WEDNESDAY

THURSDAY

FRIDAY

SATURDAY

SUNDAY

NOTES

YES
I Can!
(THIS WEEK PLANNING)

Goals:

FROM _____ TO _____

MONDAY

TUESDAY

WEDNESDAY

THURSDAY

FRIDAY

SATURDAY

SUNDAY

NOTES

YES I Can!
(THIS WEEK PLANNING)

Goals:

FROM _____ TO _____

MONDAY

TUESDAY

WEDNESDAY

THURSDAY

FRIDAY

SATURDAY

SUNDAY

NOTES

YES
I Can!
(THIS WEEK PLANNING)

Goals:

FROM _____ TO _____

MONDAY

TUESDAY

WEDNESDAY

THURSDAY

FRIDAY

SATURDAY

SUNDAY

NOTES

YES
I Can!
(THIS WEEK PLANNING)

Goals:

FROM _____ TO _____

MONDAY

TUESDAY

WEDNESDAY

THURSDAY

FRIDAY

SATURDAY

SUNDAY

NOTES

YES
I Can!
(THIS WEEK PLANNING)

Goals:

FROM _____ TO _____

MONDAY

TUESDAY

WEDNESDAY

THURSDAY

FRIDAY

SATURDAY

SUNDAY

NOTES

YES
I Can!
(THIS WEEK PLANNING)

Goals:

FROM _____ TO _____

MONDAY

TUESDAY

WEDNESDAY

THURSDAY

FRIDAY

SATURDAY

SUNDAY

NOTES

YES
I Can!
(THIS WEEK PLANNING)

Goals:

FROM _____ TO _____

MONDAY

TUESDAY

WEDNESDAY

THURSDAY

FRIDAY

SATURDAY

SUNDAY

NOTES

YES
I Can!
(THIS WEEK PLANNING)

Goals:

FROM _____ TO _____

MONDAY

TUESDAY

WEDNESDAY

THURSDAY

FRIDAY

SATURDAY

SUNDAY

NOTES

YES
I Can!
(THIS WEEK PLANNING)

Goals:

FROM _____ TO _____

MONDAY

TUESDAY

WEDNESDAY

THURSDAY

FRIDAY

SATURDAY

SUNDAY

NOTES

YES
I Can!
(THIS WEEK PLANNING)

Goals:

From _____ to _____

MONDAY

TUESDAY

WEDNESDAY

THURSDAY

FRIDAY

SATURDAY

SUNDAY

NOTES

YES
I Can!
(THIS WEEK PLANNING)

Goals:

FROM _____ TO _____

MONDAY

TUESDAY

WEDNESDAY

THURSDAY

FRIDAY

SATURDAY

SUNDAY

NOTES

YES
I Can!
(THIS WEEK PLANNING)

Goals:

FROM _____ TO _____

MONDAY

TUESDAY

WEDNESDAY

THURSDAY

FRIDAY

SATURDAY

SUNDAY

NOTES

YES
I Can!
(THIS WEEK PLANNING)

Goals:

FROM _____ TO _____

MONDAY

TUESDAY

WEDNESDAY

THURSDAY

FRIDAY

SATURDAY

SUNDAY

NOTES

YES
I Can!
(THIS WEEK PLANNING)

Goals:

FROM _____ TO _____

MONDAY

TUESDAY

WEDNESDAY

THURSDAY

FRIDAY

SATURDAY

SUNDAY

NOTES

YES I Can!
(THIS WEEK PLANNING)

Goals:

FROM _____ TO _____

MONDAY

TUESDAY

WEDNESDAY

THURSDAY

FRIDAY

SATURDAY

SUNDAY

NOTES

YES
I Can!
(THIS WEEK PLANNING)

Goals:

FROM _____ TO _____

MONDAY

TUESDAY

WEDNESDAY

THURSDAY

FRIDAY

SATURDAY

SUNDAY

NOTES

YES
I Can!
(THIS WEEK PLANNING)

Goals:

FROM _____ TO _____

MONDAY

TUESDAY

WEDNESDAY

THURSDAY

FRIDAY

SATURDAY

SUNDAY

NOTES

YES
I Can!
(THIS WEEK PLANNING)

Goals:

FROM _____ TO _____

MONDAY

TUESDAY

WEDNESDAY

THURSDAY

FRIDAY

SATURDAY

SUNDAY

NOTES

YES
I Can!
(THIS WEEK PLANNING)

Goals:

FROM _____ TO _____

MONDAY

TUESDAY

WEDNESDAY

THURSDAY

FRIDAY

SATURDAY

SUNDAY

NOTES

YES I Can!
(THIS WEEK PLANNING)

Goals:

FROM _____ TO _____

MONDAY

TUESDAY

WEDNESDAY

THURSDAY

FRIDAY

SATURDAY

SUNDAY

NOTES

YES
I Can!
(THIS WEEK PLANNING)

Goals:

FROM _____ TO _____

MONDAY

TUESDAY

WEDNESDAY

THURSDAY

FRIDAY

SATURDAY

SUNDAY

NOTES

YES
I Can!
(THIS WEEK PLANNING)

Goals:

FROM _____ TO _____

MONDAY

TUESDAY

WEDNESDAY

THURSDAY

FRIDAY

SATURDAY

SUNDAY

NOTES

YES
I Can!
(THIS WEEK PLANNING)

Goals:

FROM _____ TO _____

MONDAY

TUESDAY

WEDNESDAY

THURSDAY

FRIDAY

SATURDAY

SUNDAY

NOTES

YES
I Can!
(THIS WEEK PLANNING)

Goals:

FROM _____ TO _____

MONDAY

TUESDAY

WEDNESDAY

THURSDAY

FRIDAY

SATURDAY

SUNDAY

NOTES

YES
I Can!
(THIS WEEK PLANNING)

Goals:

FROM _____ TO _____

MONDAY

TUESDAY

WEDNESDAY

THURSDAY

FRIDAY

SATURDAY

SUNDAY

NOTES

YES I Can!
(THIS WEEK PLANNING)

Goals:

FROM _____ TO _____

MONDAY

TUESDAY

WEDNESDAY

THURSDAY

FRIDAY

SATURDAY

SUNDAY

NOTES

YES
I Can!
(THIS WEEK PLANNING)

Goals:

FROM _____ TO _____

MONDAY

TUESDAY

WEDNESDAY

THURSDAY

FRIDAY

SATURDAY

SUNDAY

NOTES

YES
I Can!
(THIS WEEK PLANNING)

Goals:

FROM _____ TO _____

MONDAY

TUESDAY

WEDNESDAY

THURSDAY

FRIDAY

SATURDAY

SUNDAY

NOTES

YES
I Can!
(THIS WEEK PLANNING)

Goals:

FROM _____ TO _____

MONDAY

TUESDAY

WEDNESDAY

THURSDAY

FRIDAY

SATURDAY

SUNDAY

NOTES

YES
I Can!
(THIS WEEK PLANNING)

Goals:

FROM _____ TO _____

MONDAY

TUESDAY

WEDNESDAY

THURSDAY

FRIDAY

SATURDAY

SUNDAY

NOTES

YES
I Can!
(THIS WEEK PLANNING)

Goals:

FROM _____ TO _____

MONDAY

TUESDAY

WEDNESDAY

THURSDAY

FRIDAY

SATURDAY

SUNDAY

NOTES

YES I Can!
(THIS WEEK PLANNING)

Goals:

FROM _____ TO _____

MONDAY

TUESDAY

WEDNESDAY

THURSDAY

FRIDAY

SATURDAY

SUNDAY

NOTES

YES
I Can!
(THIS WEEK PLANNING)

Goals:

FROM _____ TO _____

MONDAY

TUESDAY

WEDNESDAY

THURSDAY

FRIDAY

SATURDAY

SUNDAY

NOTES

YES
I Can!
(THIS WEEK PLANNING)

Goals:

FROM _____ TO _____

MONDAY

TUESDAY

WEDNESDAY

THURSDAY

FRIDAY

SATURDAY

SUNDAY

NOTES

YES I Can!
(THIS WEEK PLANNING)

Goals:

FROM _____ TO _____

MONDAY

TUESDAY

WEDNESDAY

THURSDAY

FRIDAY

SATURDAY

SUNDAY

NOTES

YES
I Can!
(THIS WEEK PLANNING)

Goals:

FROM _____ TO _____

MONDAY

TUESDAY

WEDNESDAY

THURSDAY

FRIDAY

SATURDAY

SUNDAY

NOTES

YES
I Can!
(THIS WEEK PLANNING)

Goals:

FROM _____ TO _____

MONDAY

TUESDAY

WEDNESDAY

THURSDAY

FRIDAY

SATURDAY

SUNDAY

NOTES

YES
I Can!
(THIS WEEK PLANNING)

Goals:

FROM _____ TO _____

MONDAY

TUESDAY

WEDNESDAY

THURSDAY

FRIDAY

SATURDAY

SUNDAY

NOTES

YES
I Can!
(THIS WEEK PLANNING)

Goals:

FROM _____ TO _____

MONDAY

TUESDAY

WEDNESDAY

THURSDAY

FRIDAY

SATURDAY

SUNDAY

NOTES

YES
I Can!
(THIS WEEK PLANNING)

Goals:

FROM _____ TO _____

MONDAY

TUESDAY

WEDNESDAY

THURSDAY

FRIDAY

SATURDAY

SUNDAY

NOTES

YES
I Can!
(THIS WEEK PLANNING)

Goals:

FROM _____ TO _____

MONDAY

TUESDAY

WEDNESDAY

THURSDAY

FRIDAY

SATURDAY

SUNDAY

NOTES

YES I Can!
(THIS WEEK PLANNING)

Goals:

FROM _____ TO _____

MONDAY

TUESDAY

WEDNESDAY

THURSDAY

FRIDAY

SATURDAY

SUNDAY

NOTES

YES
I Can!
(THIS WEEK PLANNING)

Goals:

FROM _____ TO _____

MONDAY

TUESDAY

WEDNESDAY

THURSDAY

FRIDAY

SATURDAY

SUNDAY

NOTES

YES
I Can!
(THIS WEEK PLANNING)

FROM _____ TO _____

Goals:

MONDAY

TUESDAY

WEDNESDAY

THURSDAY

FRIDAY

SATURDAY

SUNDAY

NOTES

YES
I Can!
(THIS WEEK PLANNING)

Goals:

FROM _____ TO _____

MONDAY

TUESDAY

WEDNESDAY

THURSDAY

FRIDAY

SATURDAY

SUNDAY

NOTES

YES
I Can!
(THIS WEEK PLANNING)

Goals:

FROM _____ TO _____

MONDAY

TUESDAY

WEDNESDAY

THURSDAY

FRIDAY

SATURDAY

SUNDAY

NOTES

YES
I Can!
(THIS WEEK PLANNING)

Goals:

FROM _____ TO _____

MONDAY

TUESDAY

WEDNESDAY

THURSDAY

FRIDAY

SATURDAY

SUNDAY

NOTES

YES
I Can!
(THIS WEEK PLANNING)

Goals:

FROM _____ TO _____

MONDAY

TUESDAY

WEDNESDAY

THURSDAY

FRIDAY

SATURDAY

SUNDAY

NOTES

YES
I Can!
(THIS WEEK PLANNING)

Goals:

FROM _____ TO _____

MONDAY

TUESDAY

WEDNESDAY

THURSDAY

FRIDAY

SATURDAY

SUNDAY

NOTES

YES
I Can!
(THIS WEEK PLANNING)

Goals:

From _____ to _____

MONDAY

TUESDAY

WEDNESDAY

THURSDAY

FRIDAY

SATURDAY

SUNDAY

NOTES

YES
I Can!
(THIS WEEK PLANNING)

Goals:

From _____ to _____

MONDAY

TUESDAY

WEDNESDAY

THURSDAY

FRIDAY

SATURDAY

SUNDAY

NOTES

YES
I Can!
(THIS WEEK PLANNING)

Goals:

FROM _____ TO _____

MONDAY

TUESDAY

WEDNESDAY

THURSDAY

FRIDAY

SATURDAY

SUNDAY

NOTES

YES
I Can!
(THIS WEEK PLANNING)

Goals:

FROM _____ TO _____

MONDAY

TUESDAY

WEDNESDAY

THURSDAY

FRIDAY

SATURDAY

SUNDAY

NOTES

YES
I Can!
(THIS WEEK PLANNING)

Goals:

FROM _____ TO _____

MONDAY

TUESDAY

WEDNESDAY

THURSDAY

FRIDAY

SATURDAY

SUNDAY

NOTES

YES
I Can!
(THIS WEEK PLANNING)

Goals:

From _____ to _____

MONDAY

TUESDAY

WEDNESDAY

THURSDAY

FRIDAY

SATURDAY

SUNDAY

NOTES

YES
I Can!
(THIS WEEK PLANNING)

Goals:

FROM _____ TO _____

MONDAY

TUESDAY

WEDNESDAY

THURSDAY

FRIDAY

SATURDAY

SUNDAY

NOTES

YES
I Can!
(THIS WEEK PLANNING)

Goals:

FROM _____ TO _____

MONDAY

TUESDAY

WEDNESDAY

THURSDAY

FRIDAY

SATURDAY

SUNDAY

NOTES

YES
I Can!
(THIS WEEK PLANNING)

Goals:

FROM _____ TO _____

MONDAY

TUESDAY

WEDNESDAY

THURSDAY

FRIDAY

SATURDAY

SUNDAY

NOTES

YES I Can!
(THIS WEEK PLANNING)

Goals:

FROM _____ TO _____

MONDAY

TUESDAY

WEDNESDAY

THURSDAY

FRIDAY

SATURDAY

SUNDAY

NOTES

YES
I Can!
(THIS WEEK PLANNING)

Goals:

FROM _____ TO _____

MONDAY

TUESDAY

WEDNESDAY

THURSDAY

FRIDAY

SATURDAY

SUNDAY

NOTES

YES
I Can!
(THIS WEEK PLANNING)

Goals:

FROM _____ TO _____

MONDAY

TUESDAY

WEDNESDAY

THURSDAY

FRIDAY

SATURDAY

SUNDAY

NOTES

www.ingramcontent.com/pod-product-compliance
Lightning Source LLC
Chambersburg PA
CBHW082114220526
45472CB00009B/2174